My Own Digital Art Paintings: Diamond Cube.

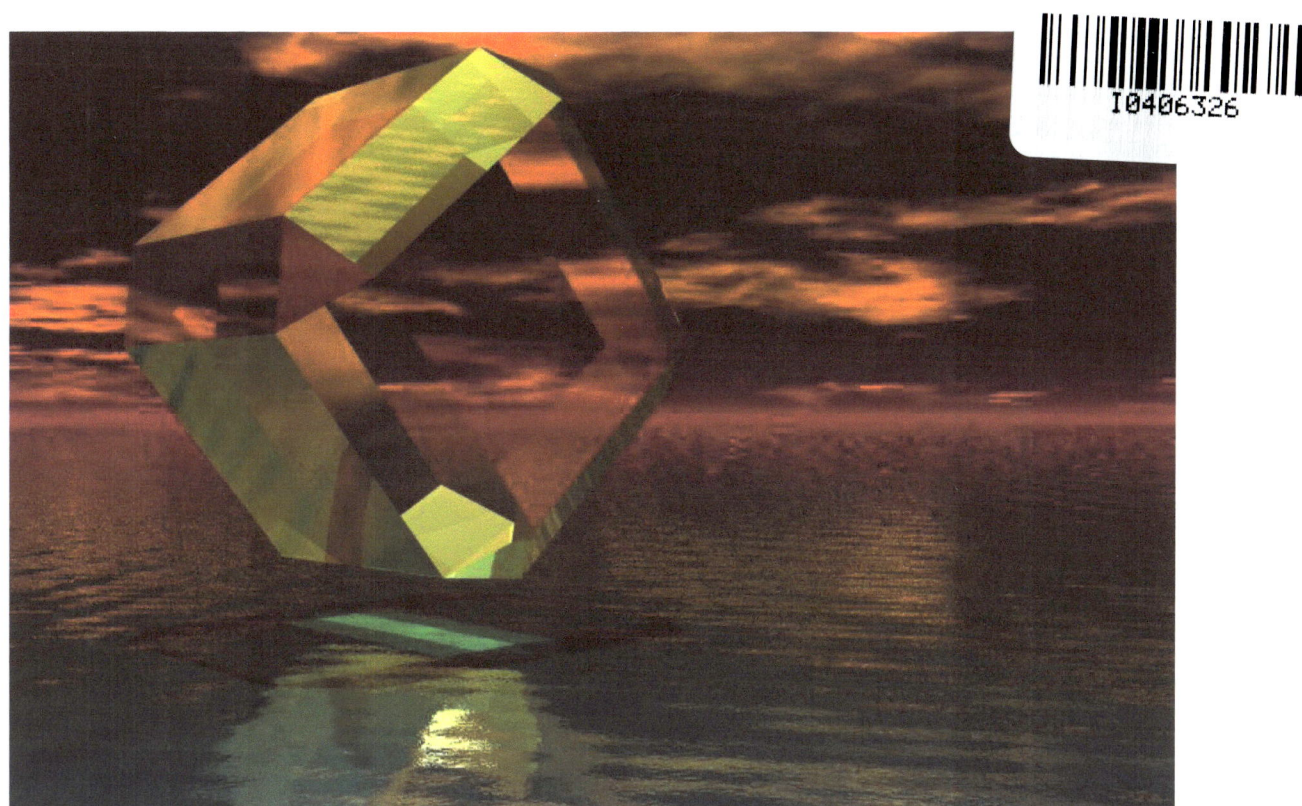

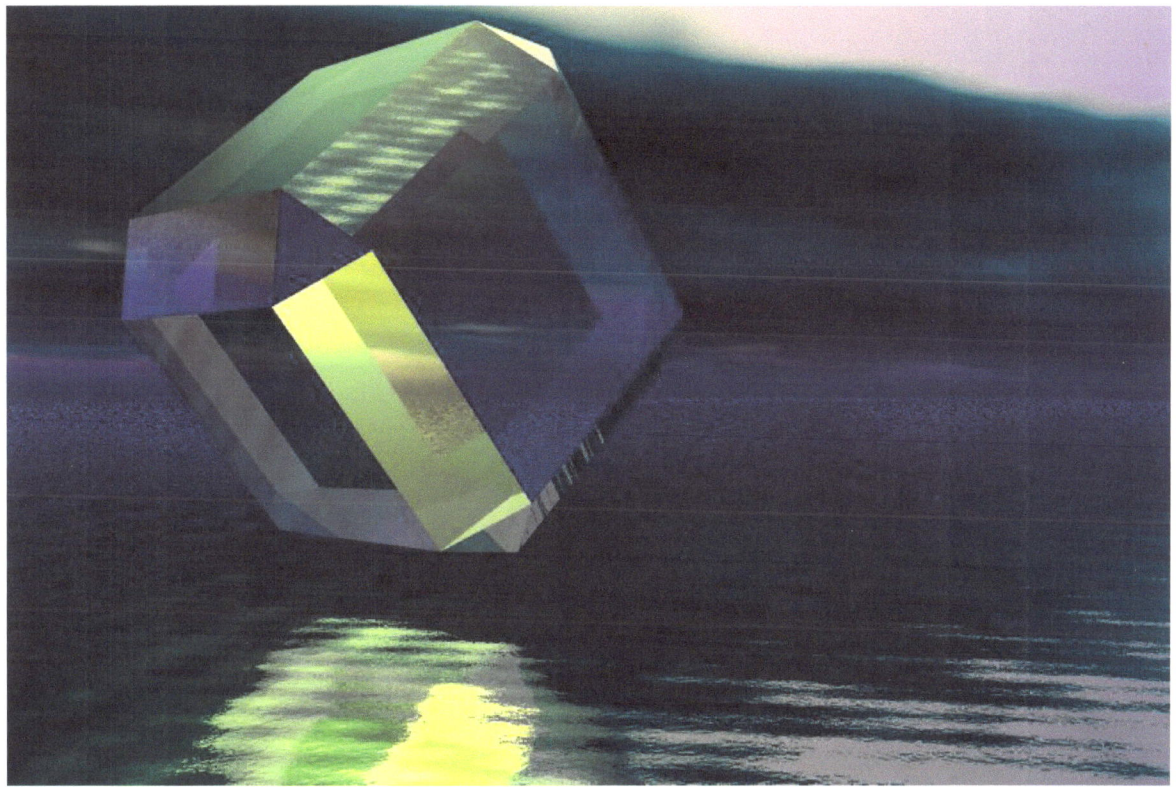

Frank Benson:

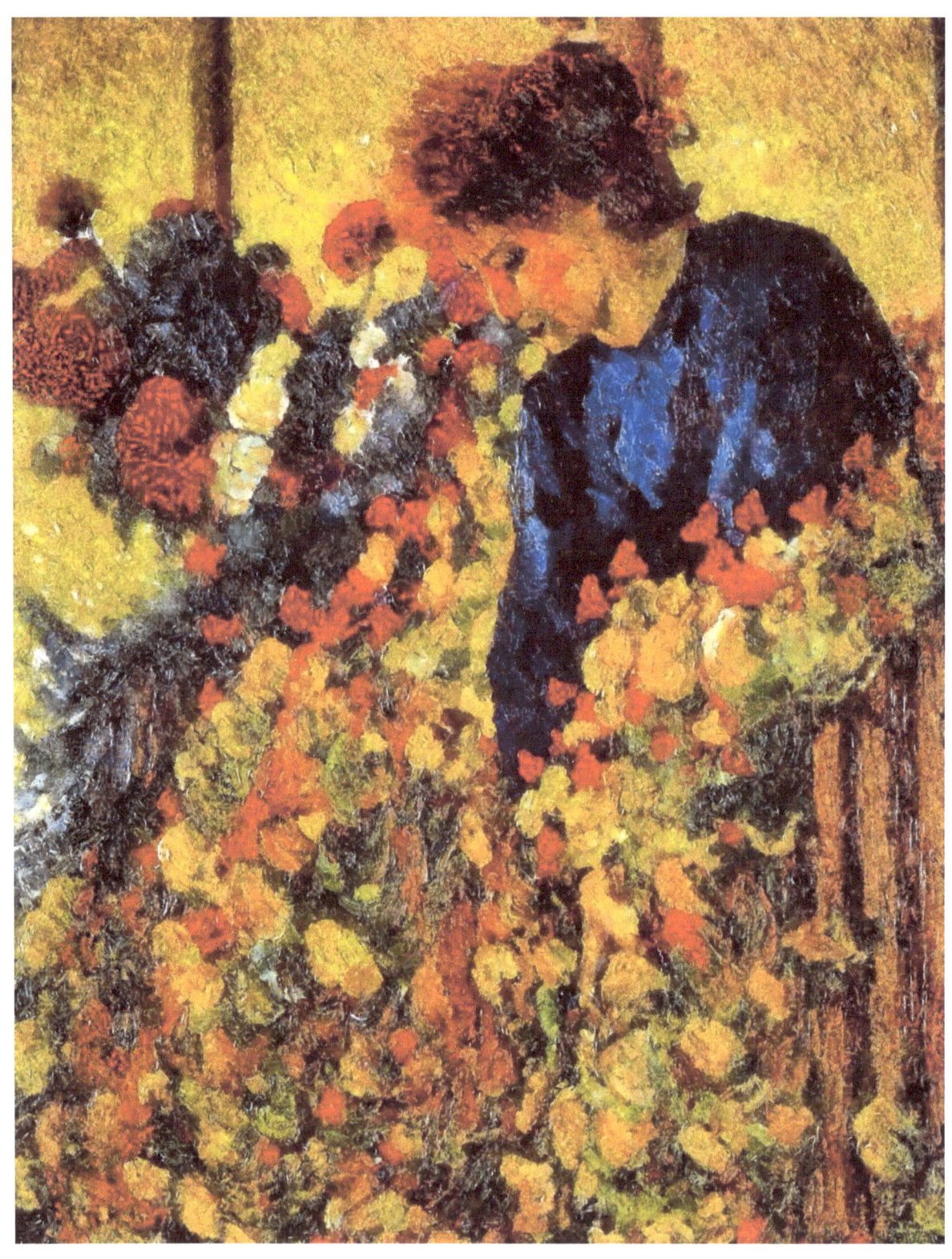

Claude Monet: River Seine.

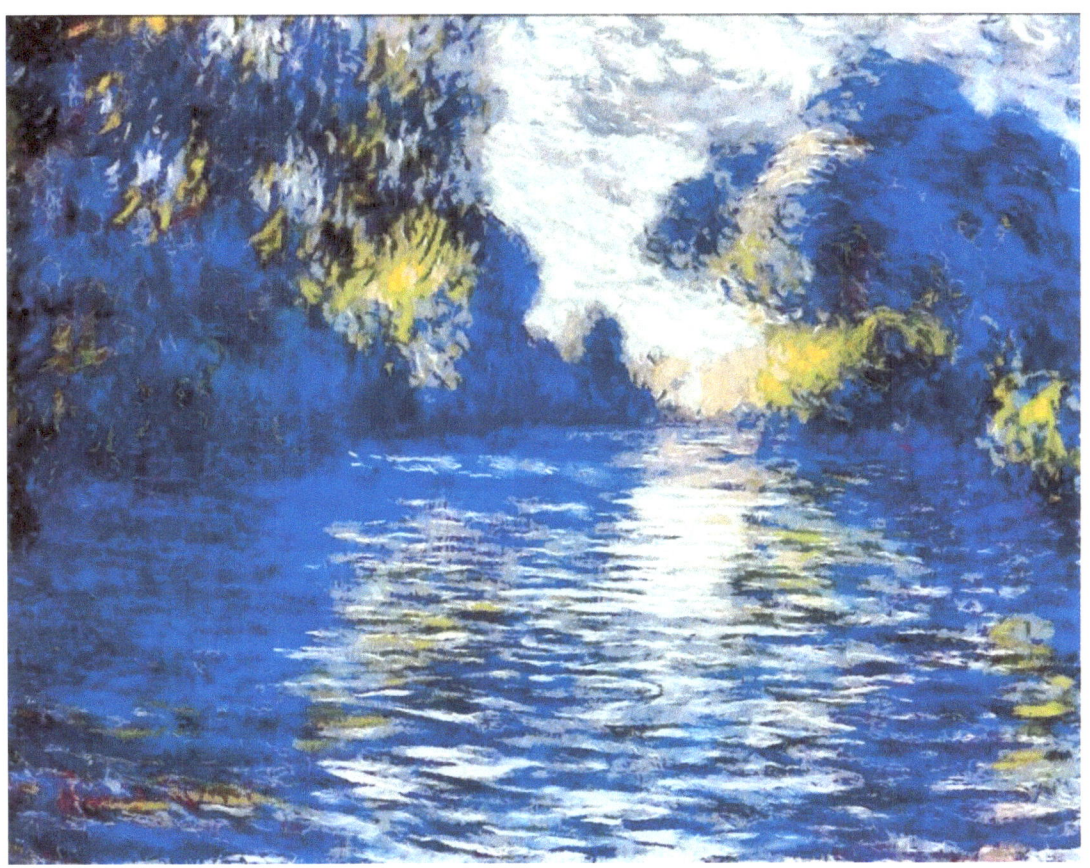

Diamond Art:

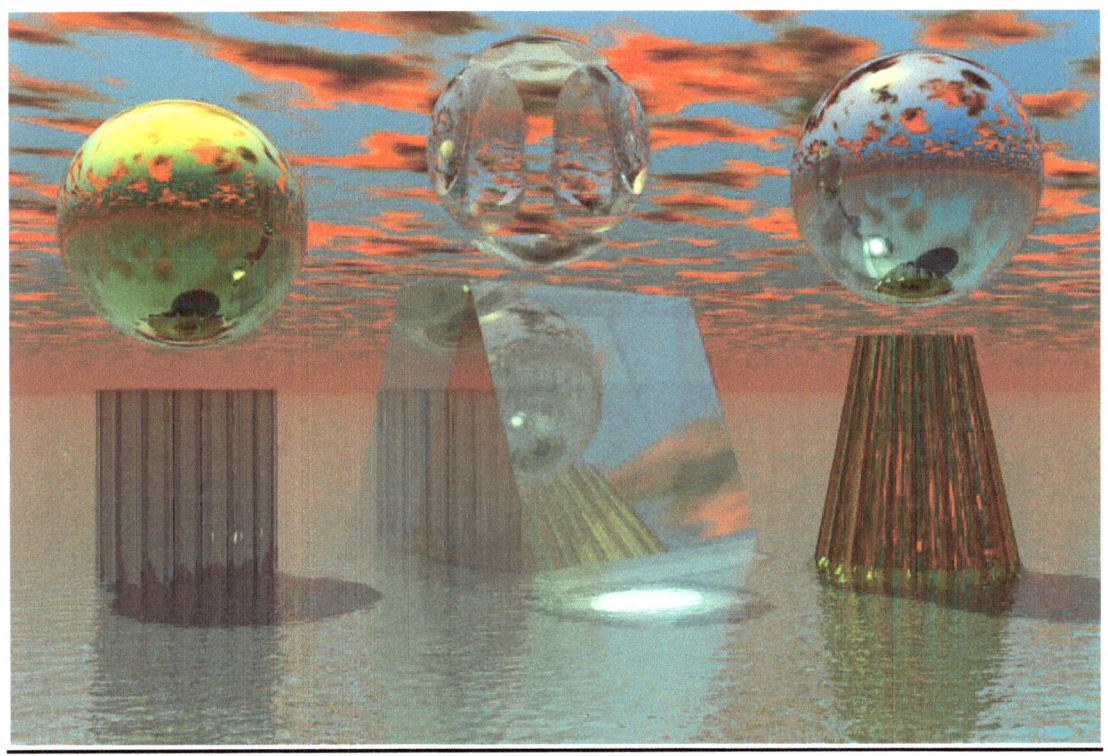

Van Gogh: Daffodils:

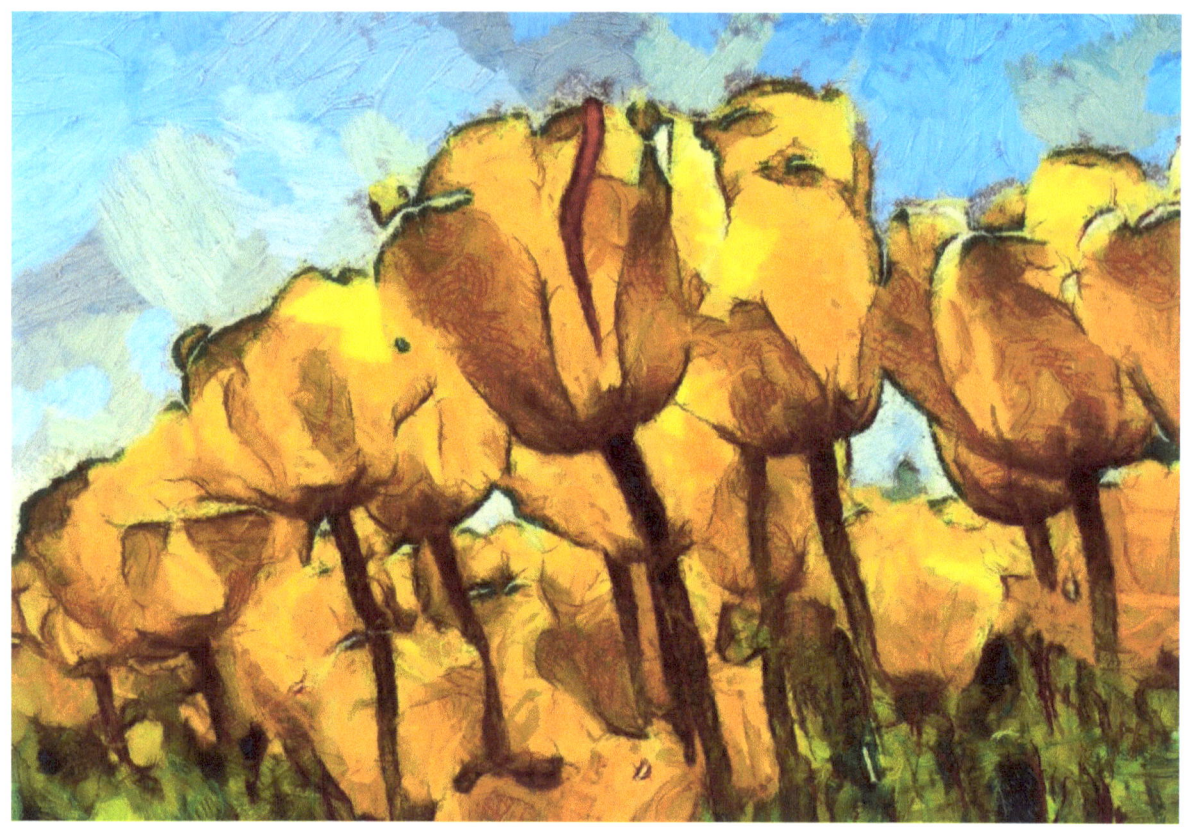

Cezanne: Eiffel Tower.

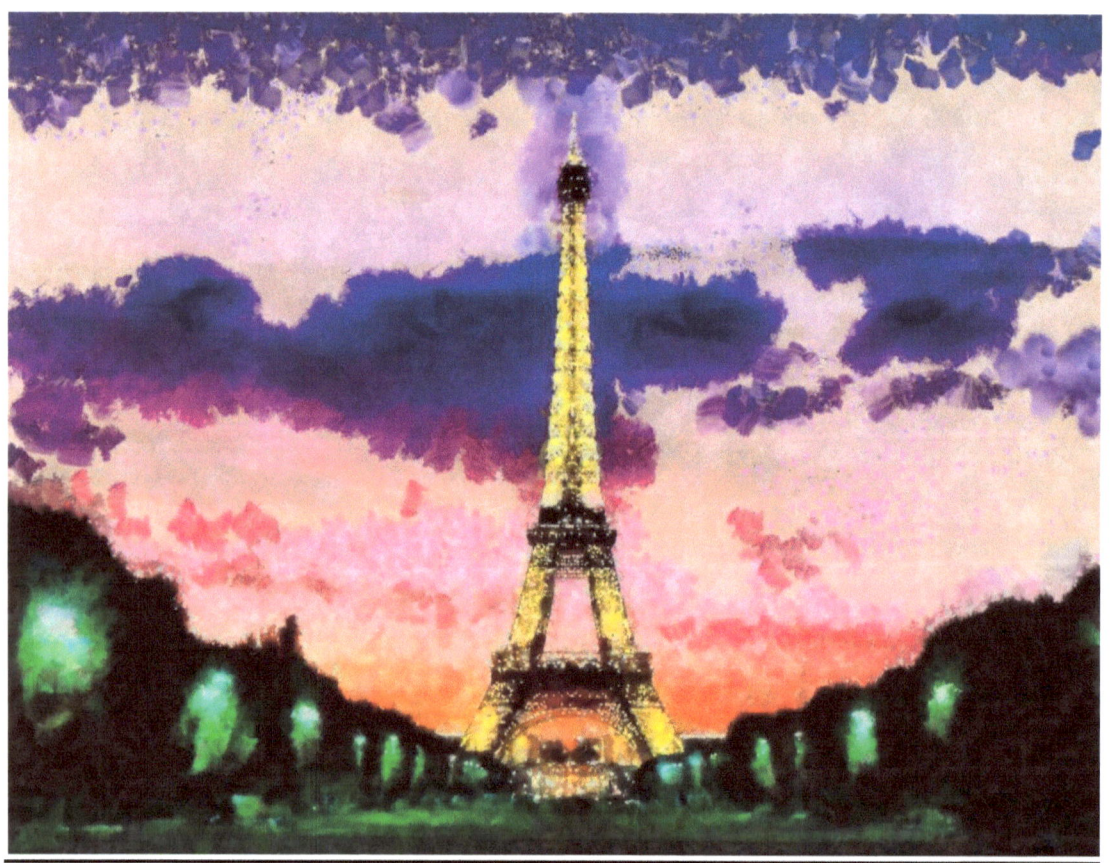

Chinese Oriental Art:

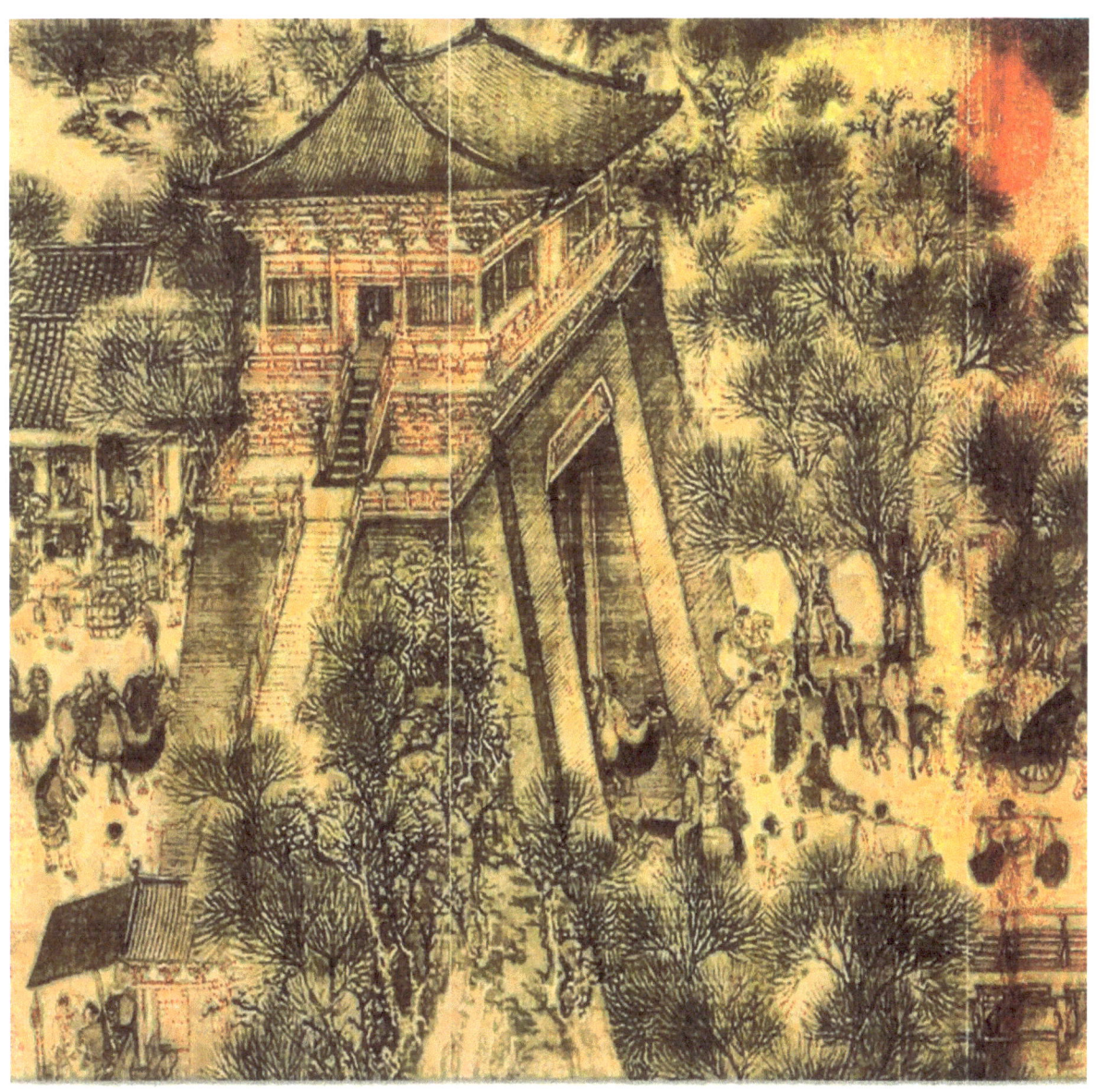

Van Gogh: Lotus Flower.

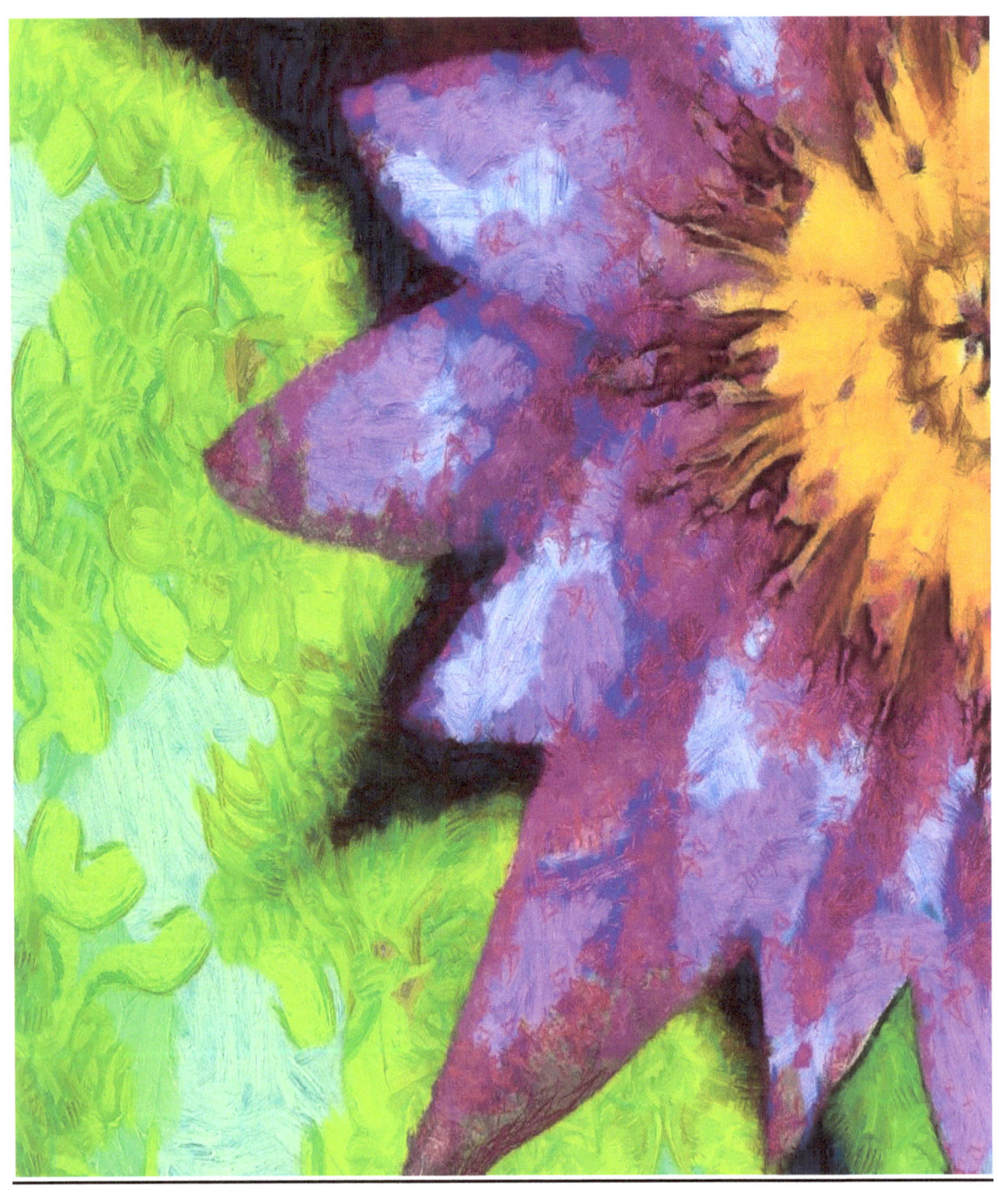

Pablo Picasso:

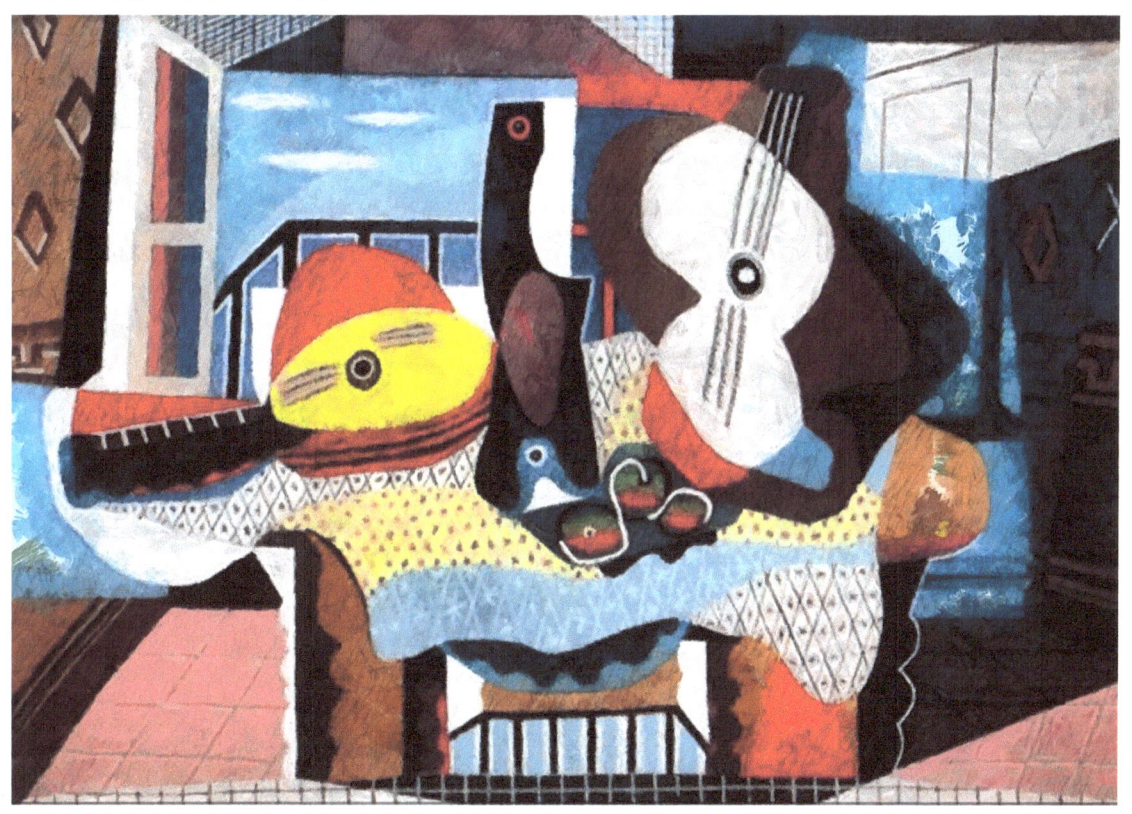

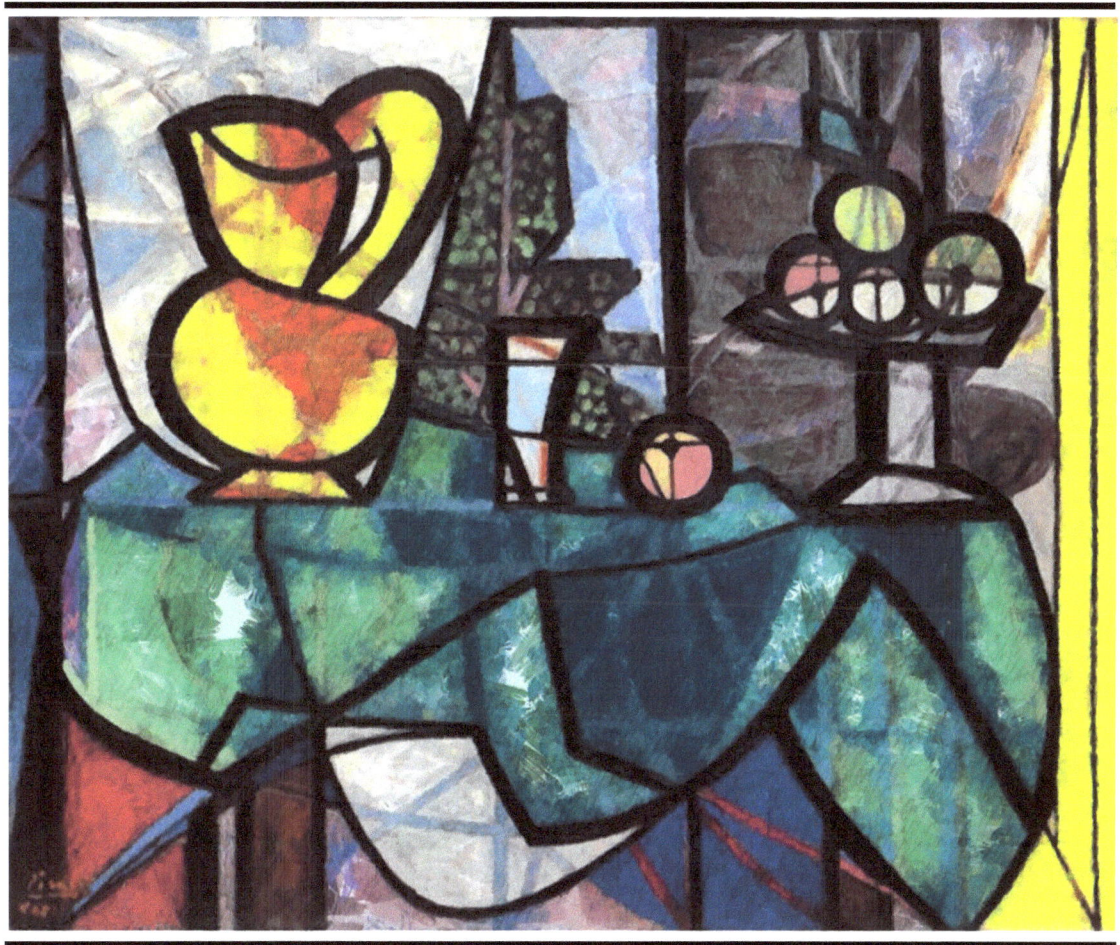

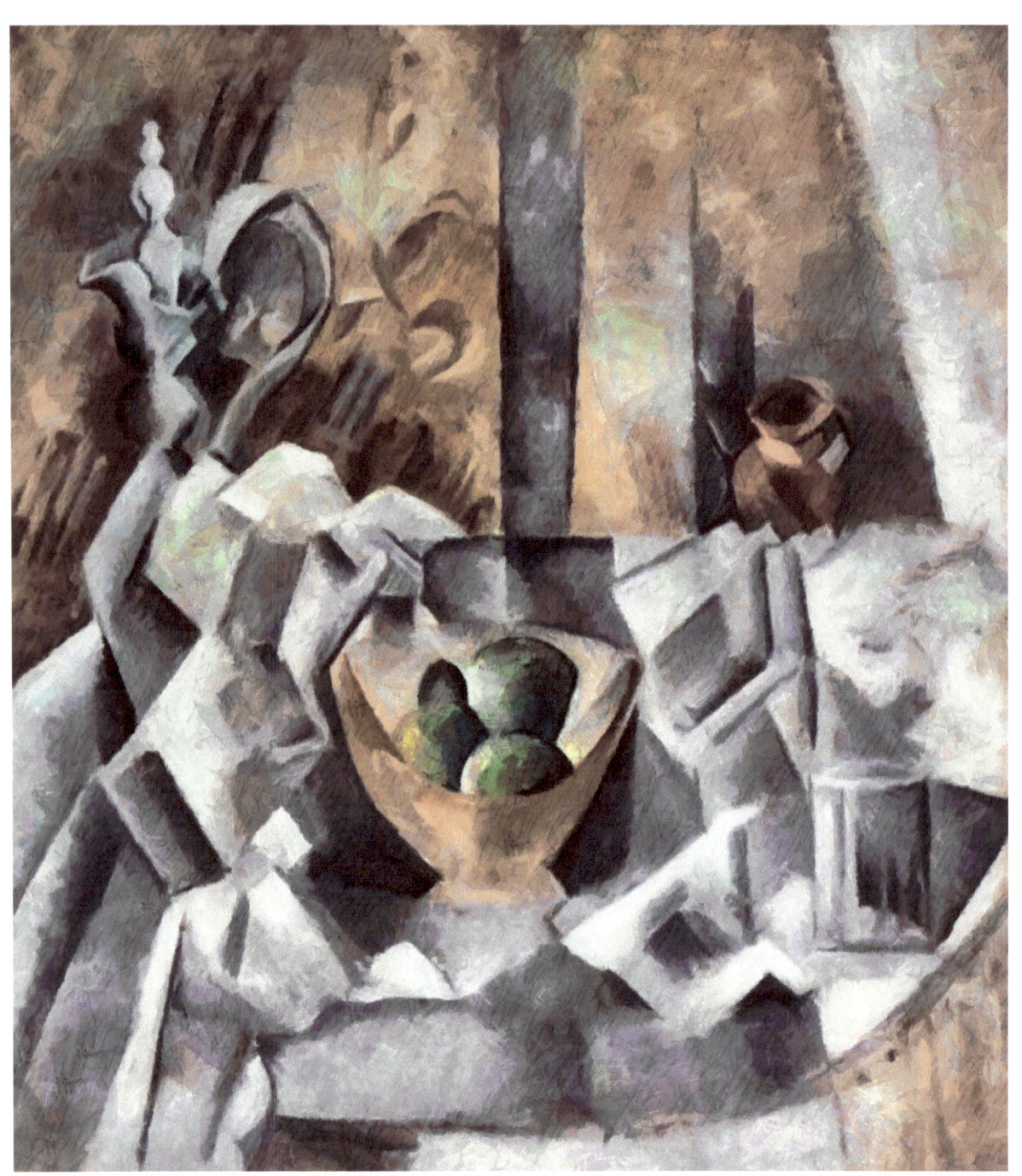

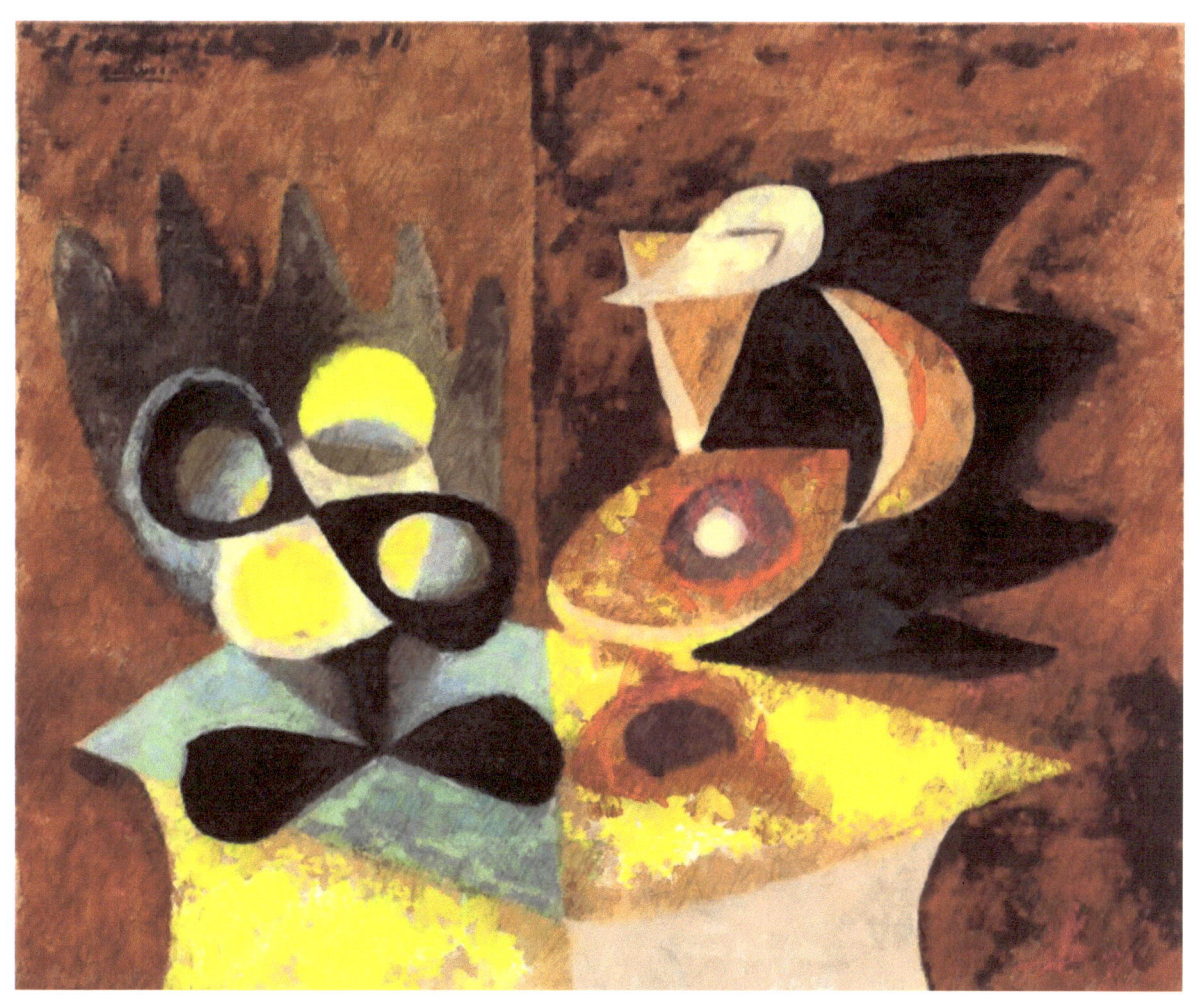

Claude Monet: Butterfly.

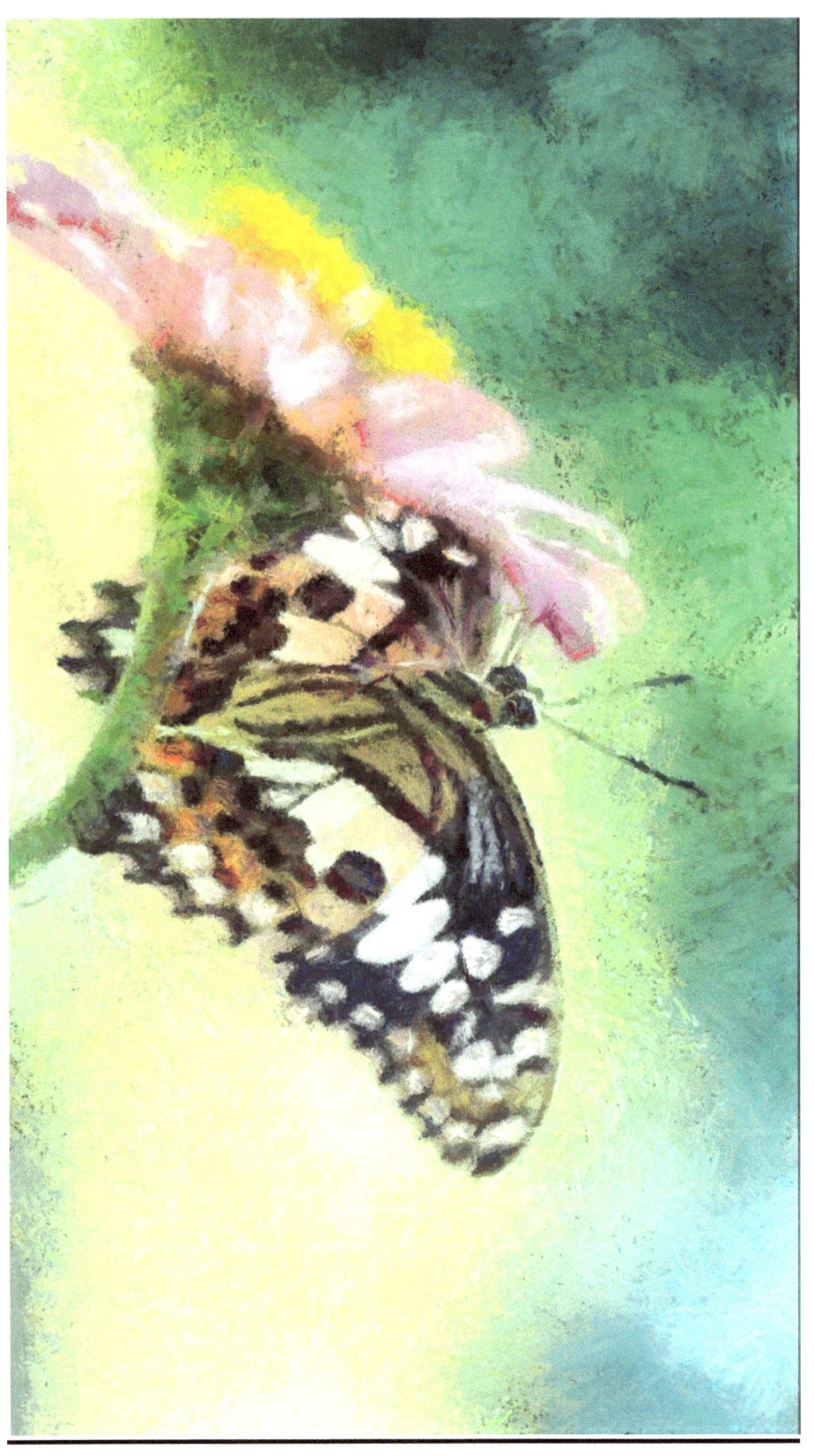

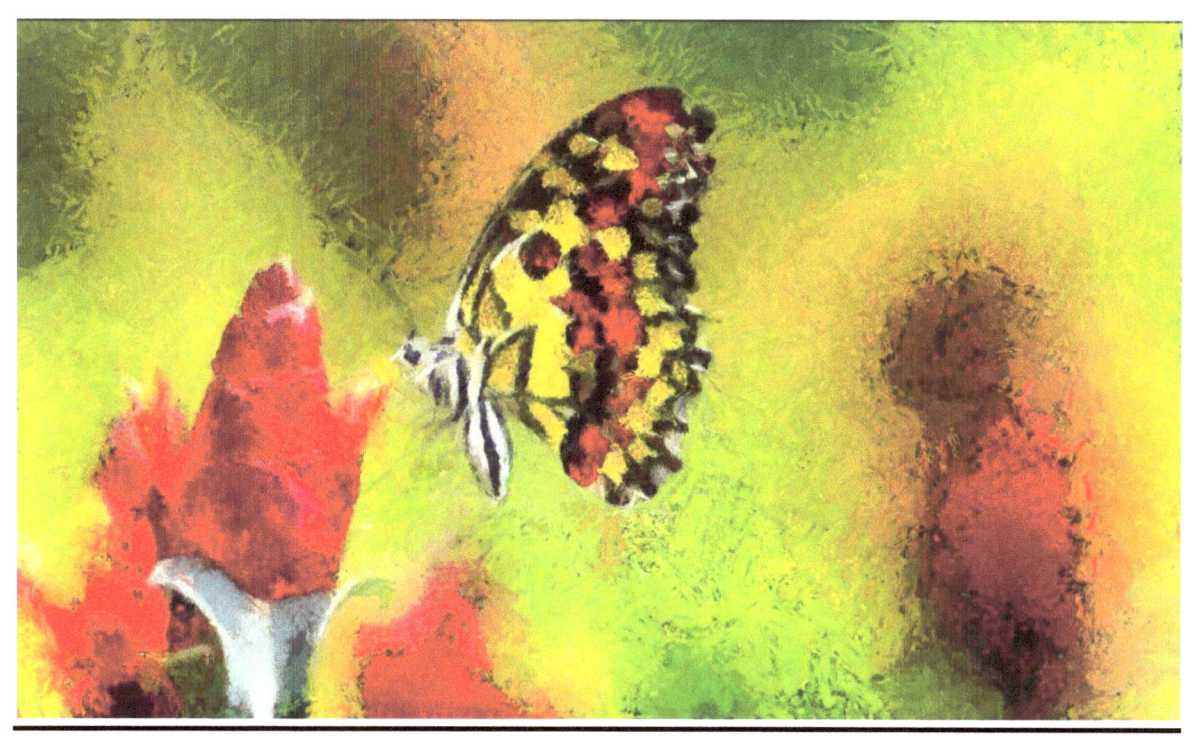

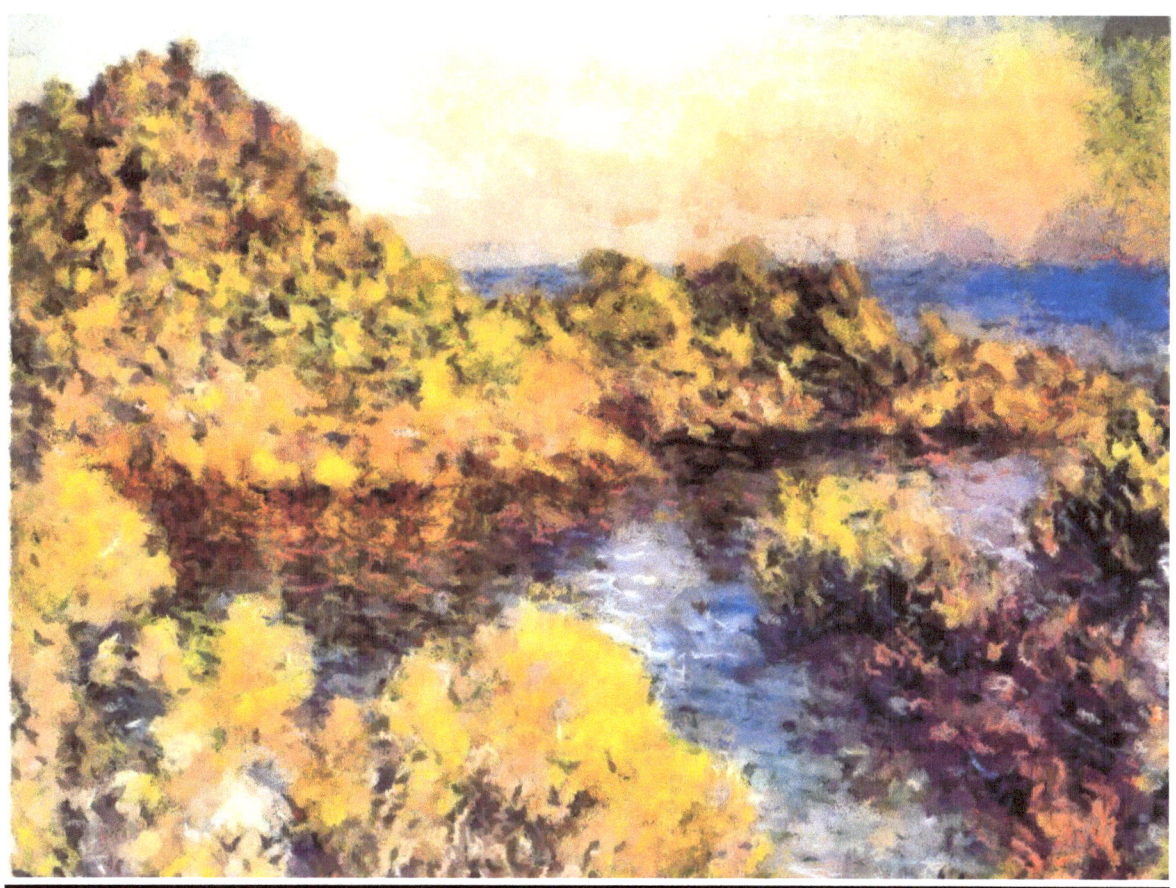

Claude Monet (contd).

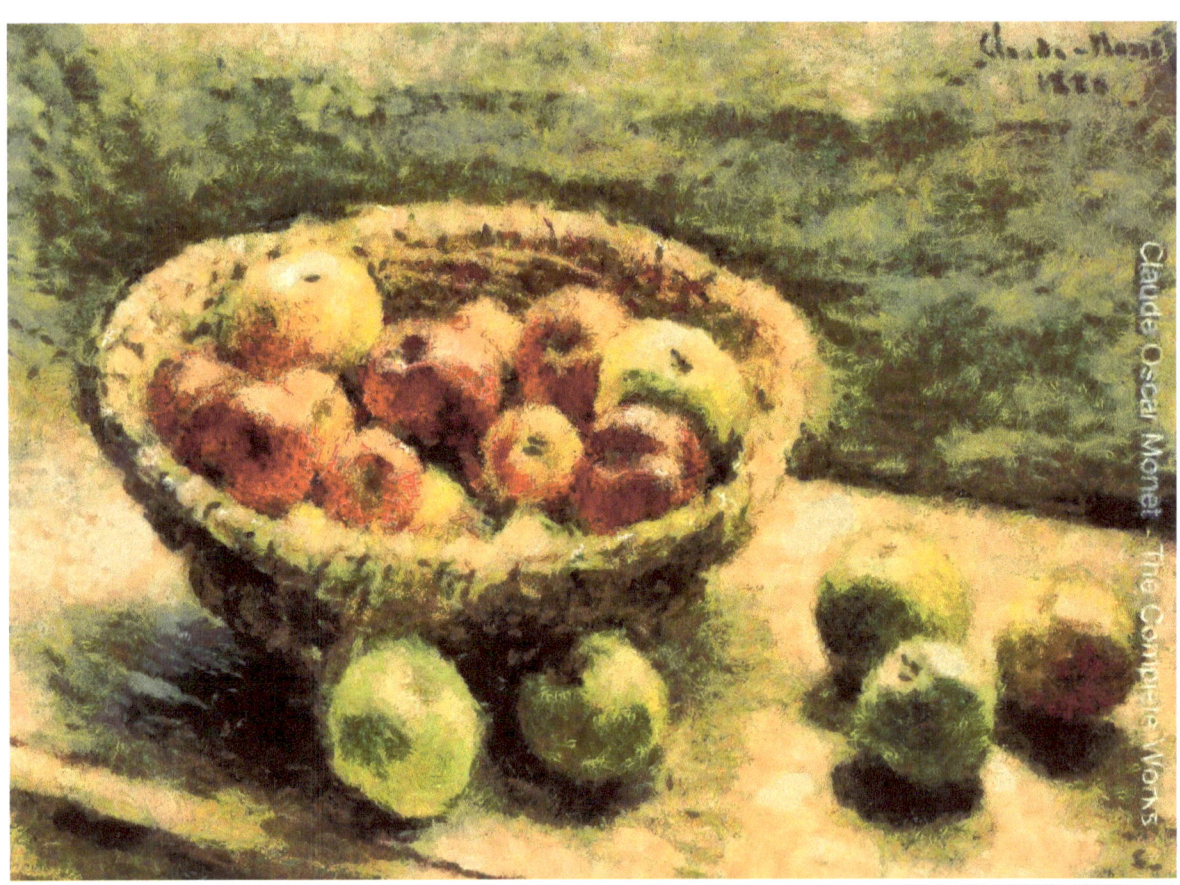

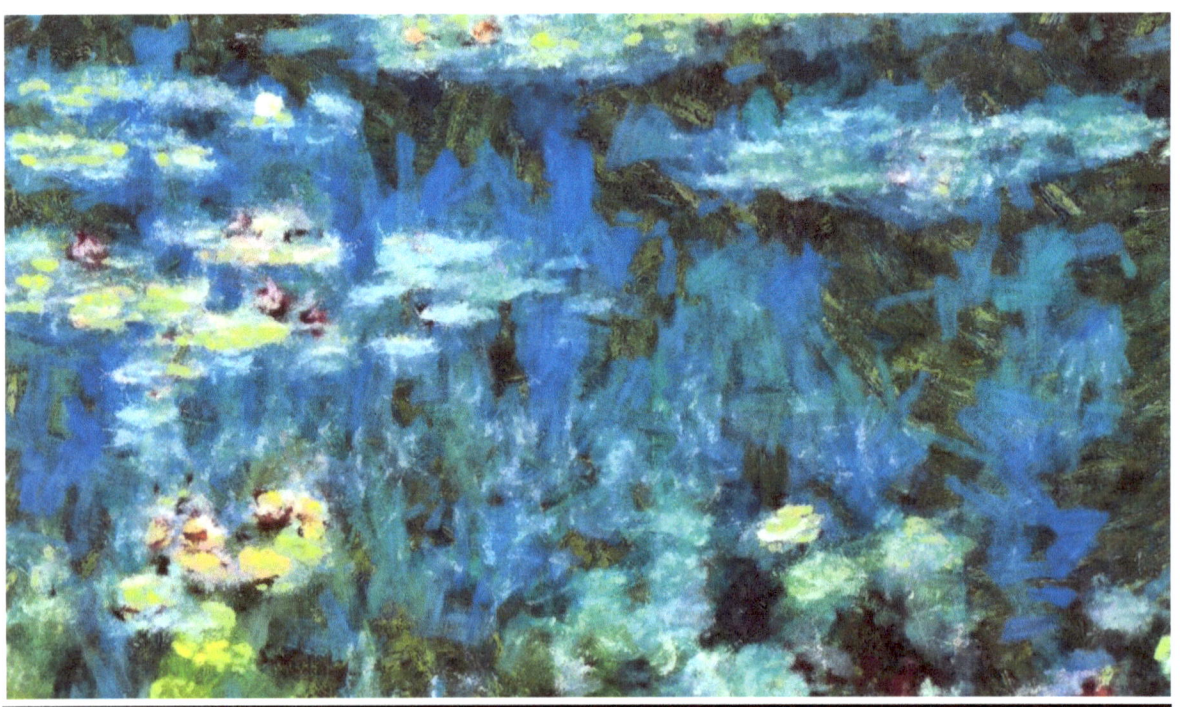

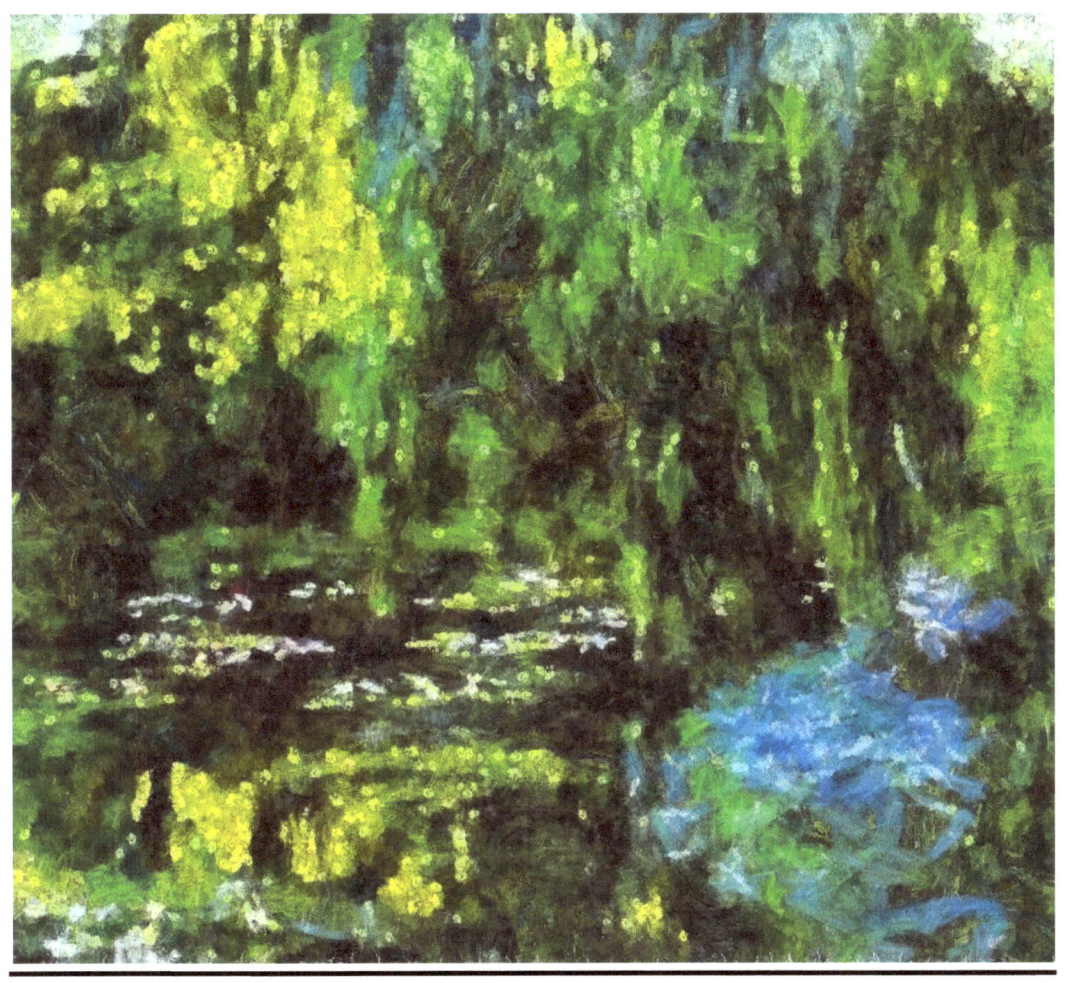

Vincent Van Gogh:

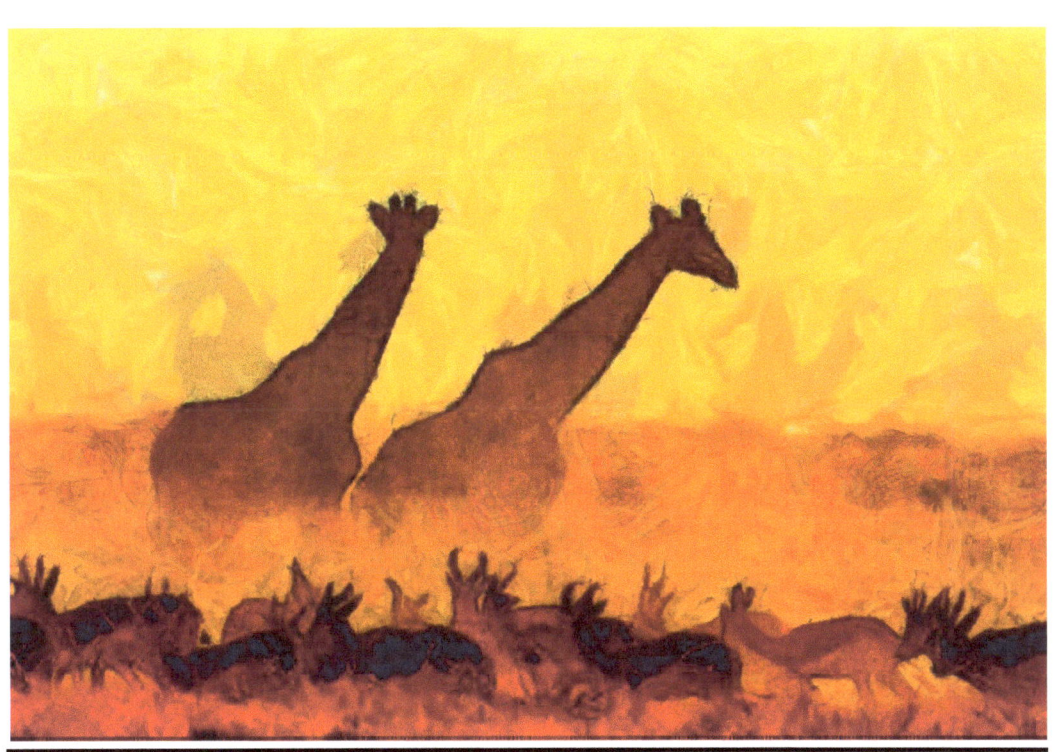

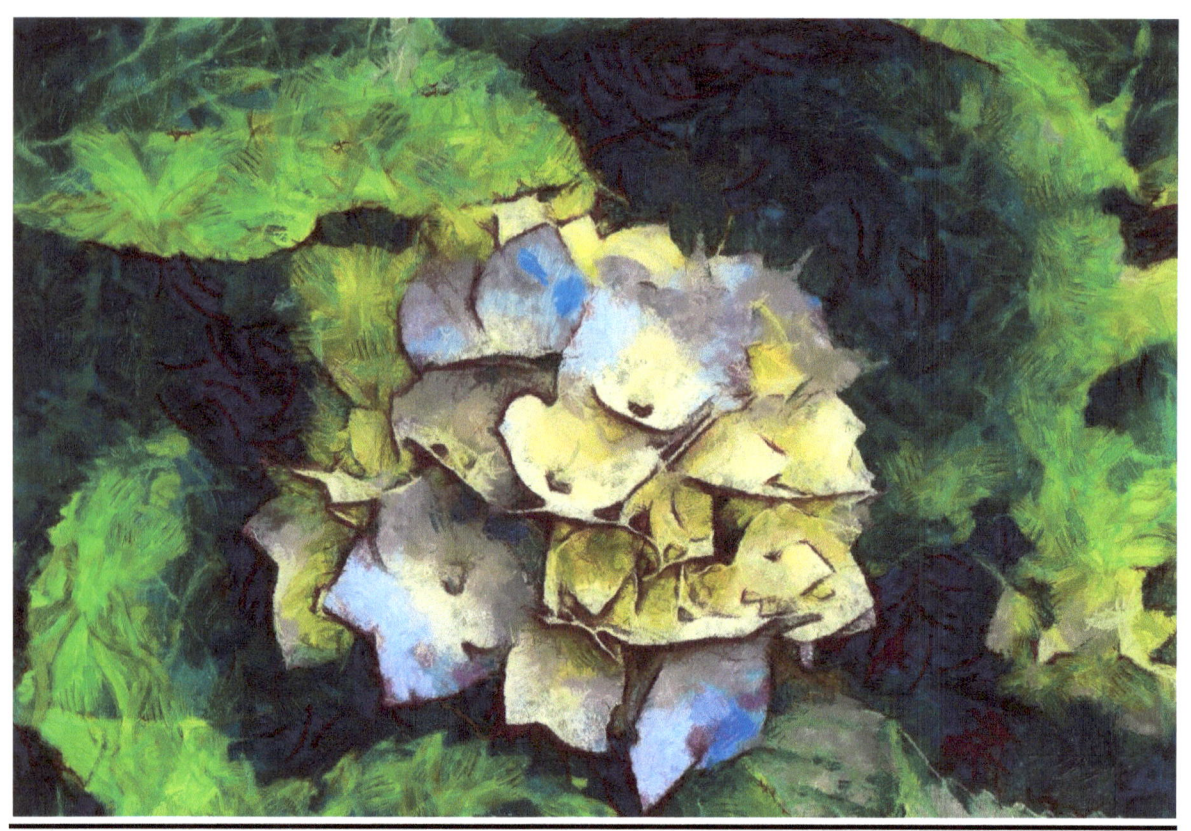

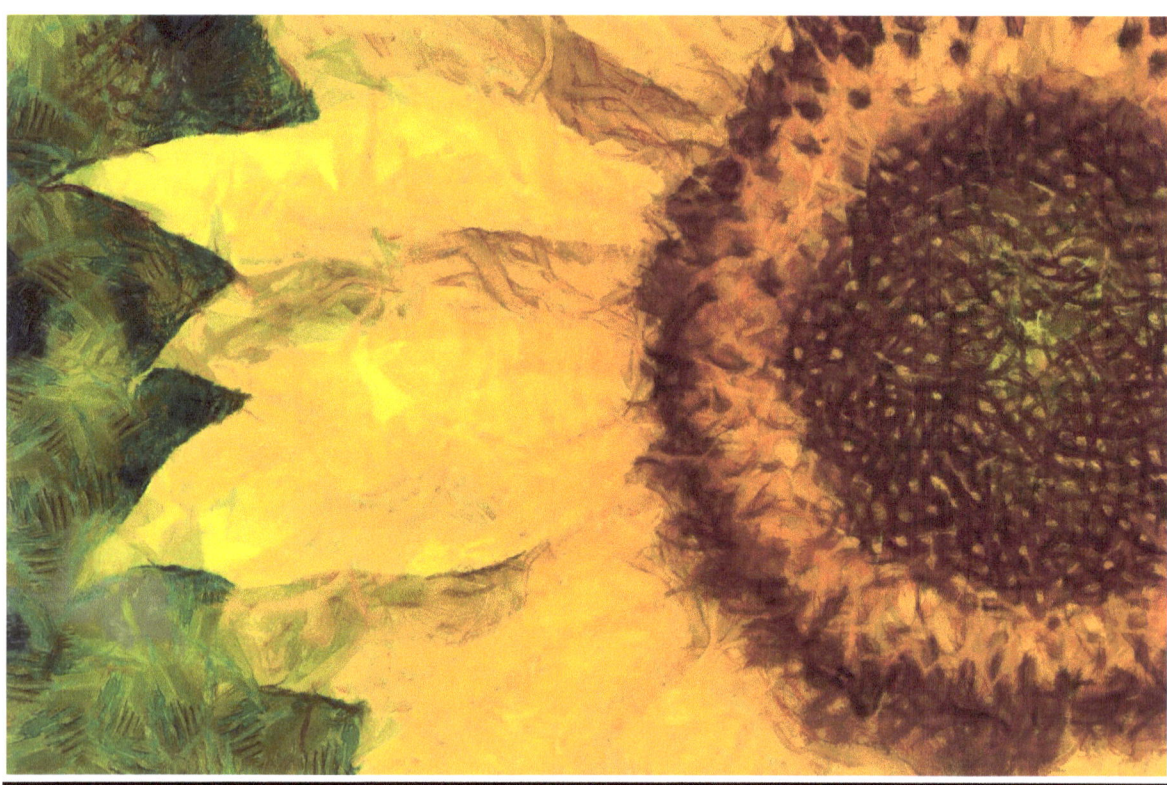

Van Gogh: Tuscany.

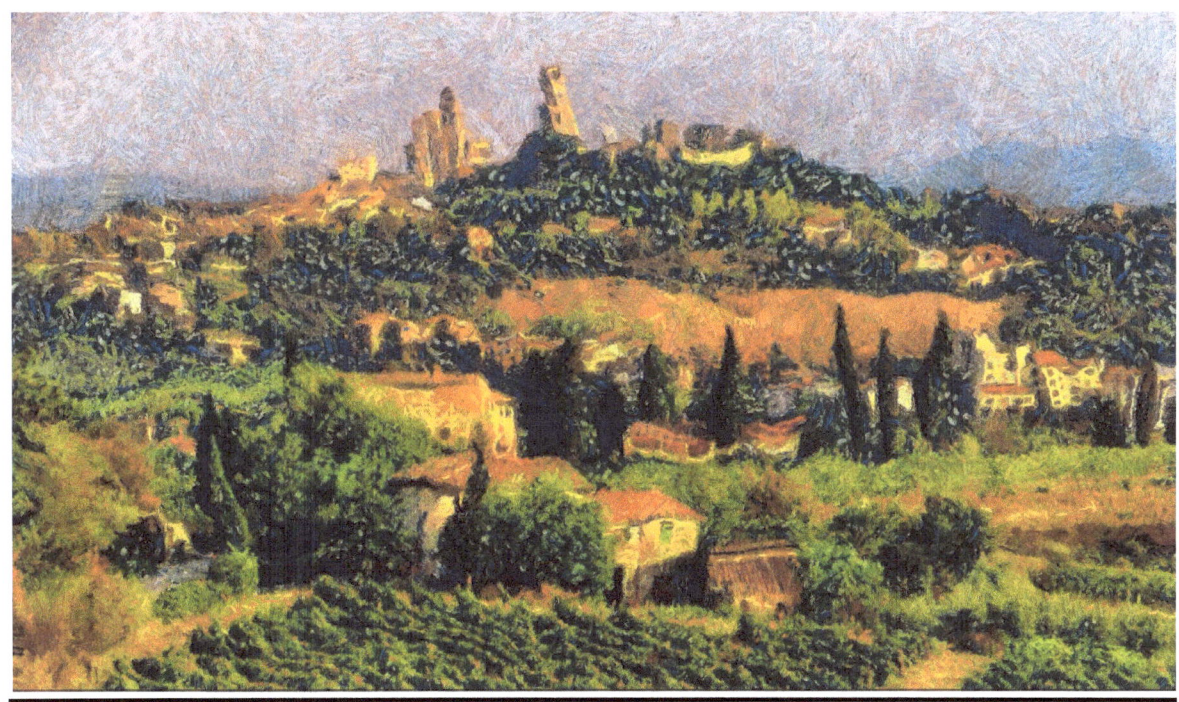

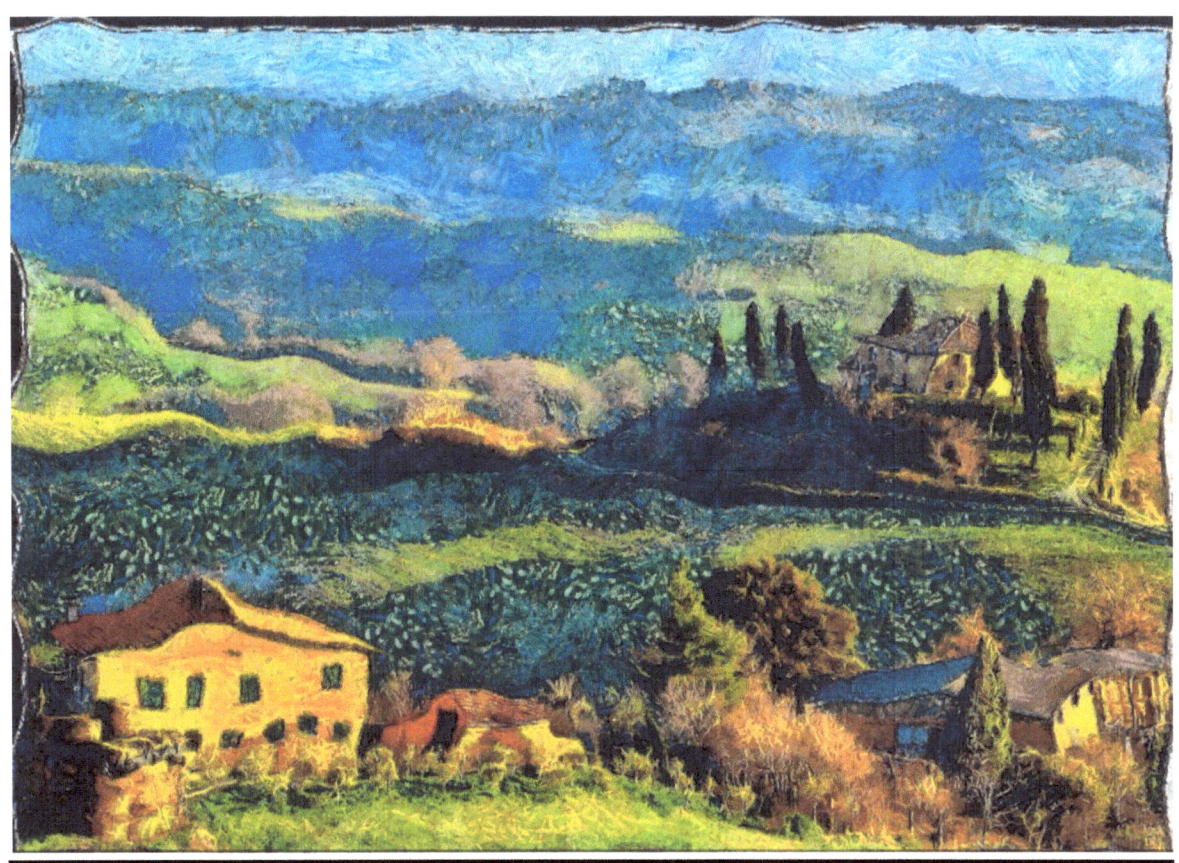

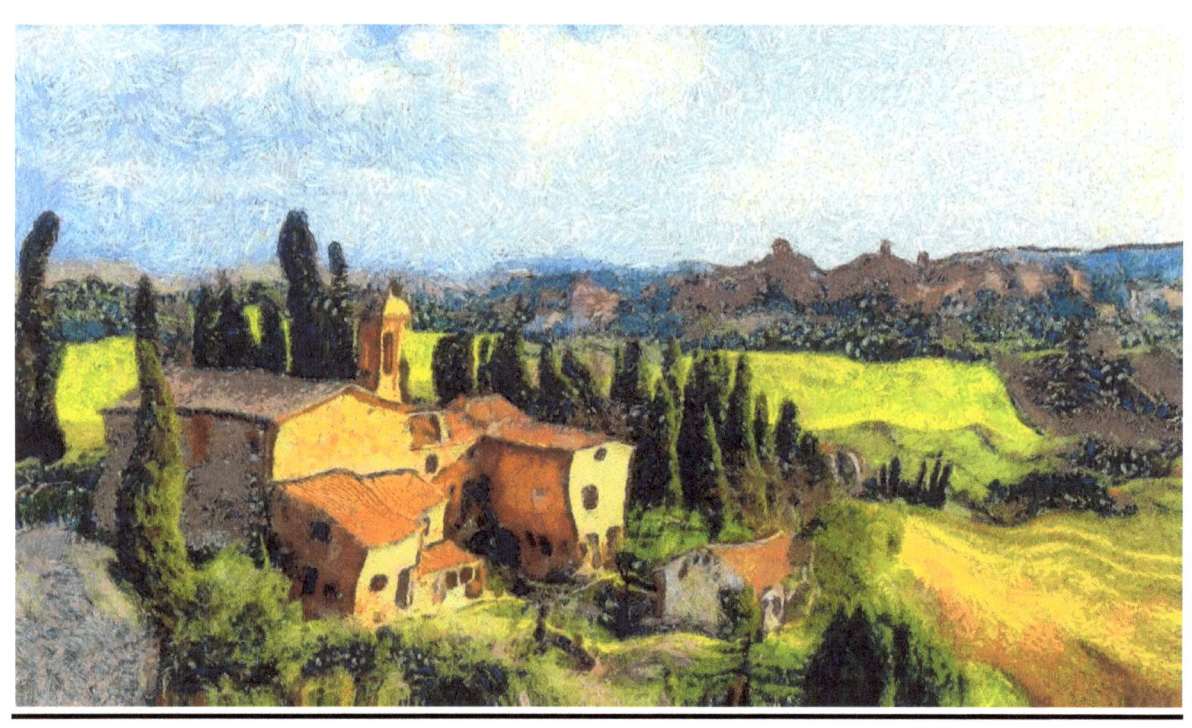

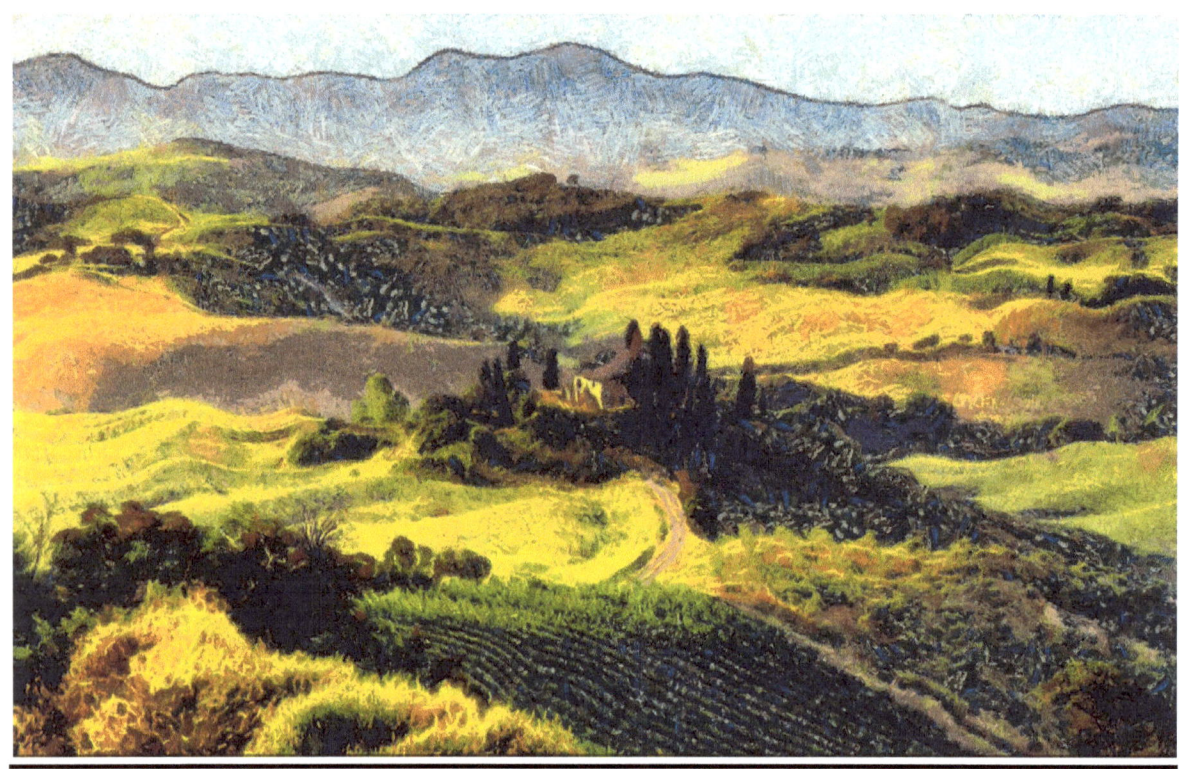

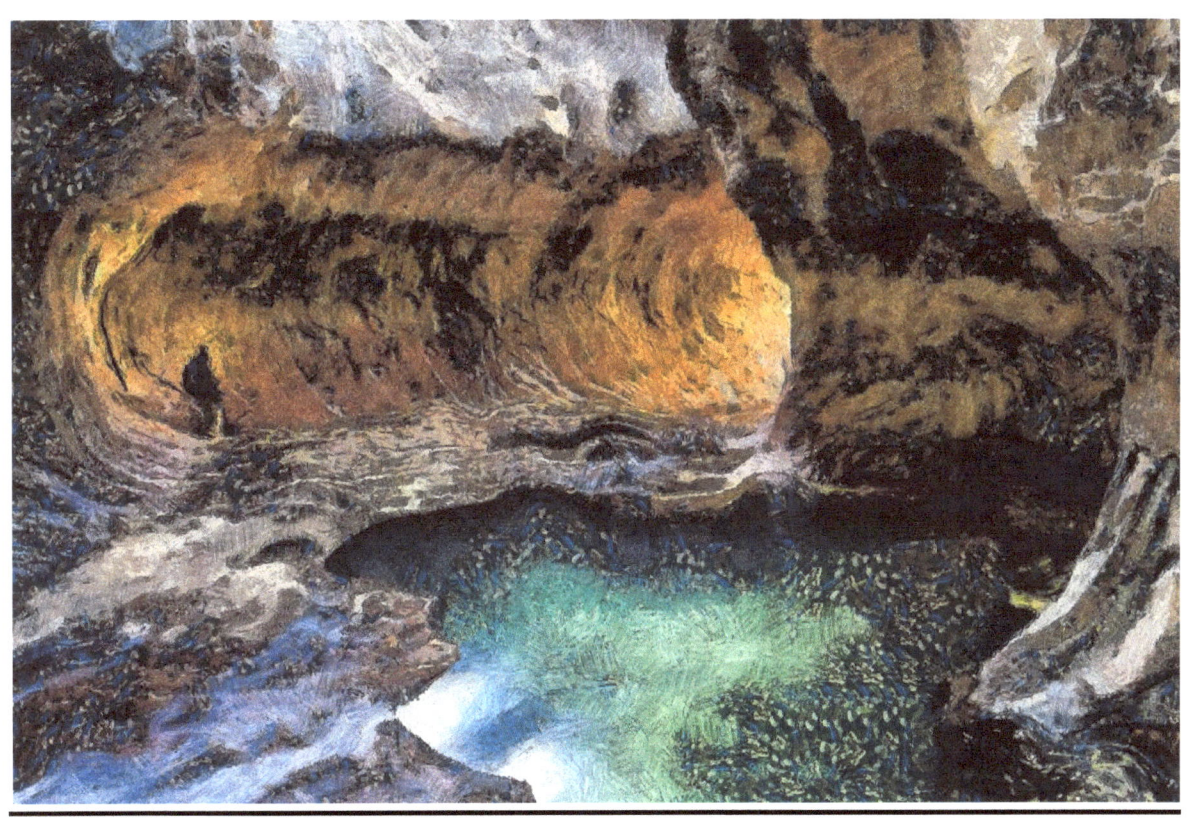

Above: Zion National Park, USA.

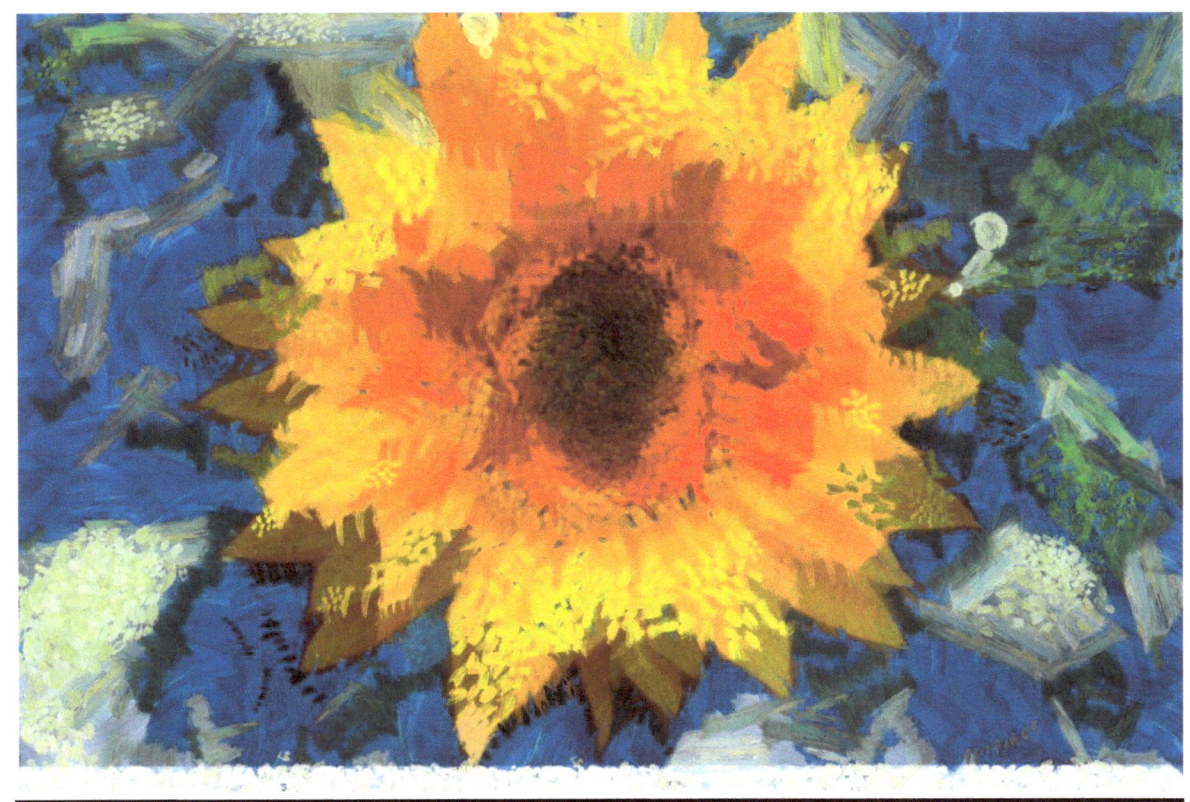

Heavy Paintwork (no particular style):

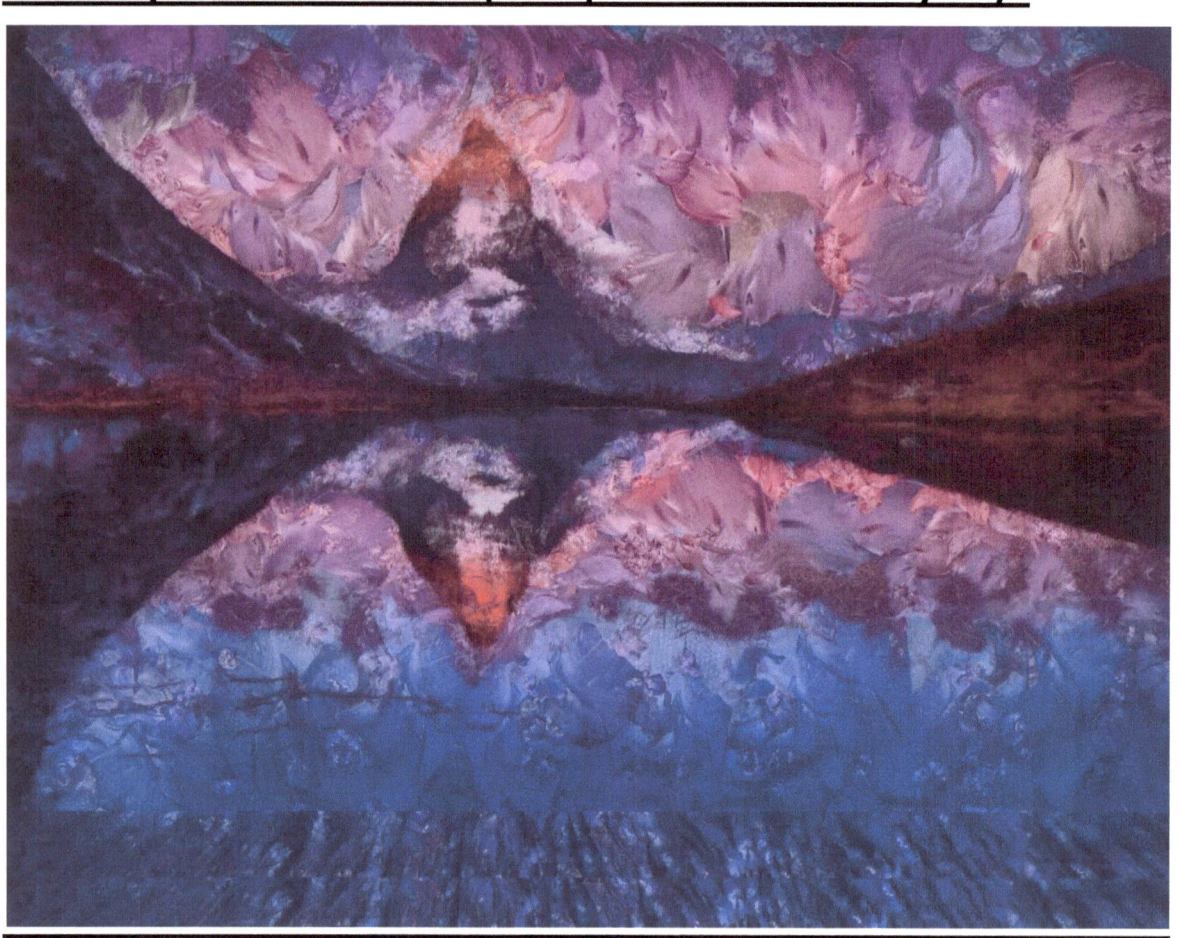

(Original Art: Matterhorn, Switzerland)

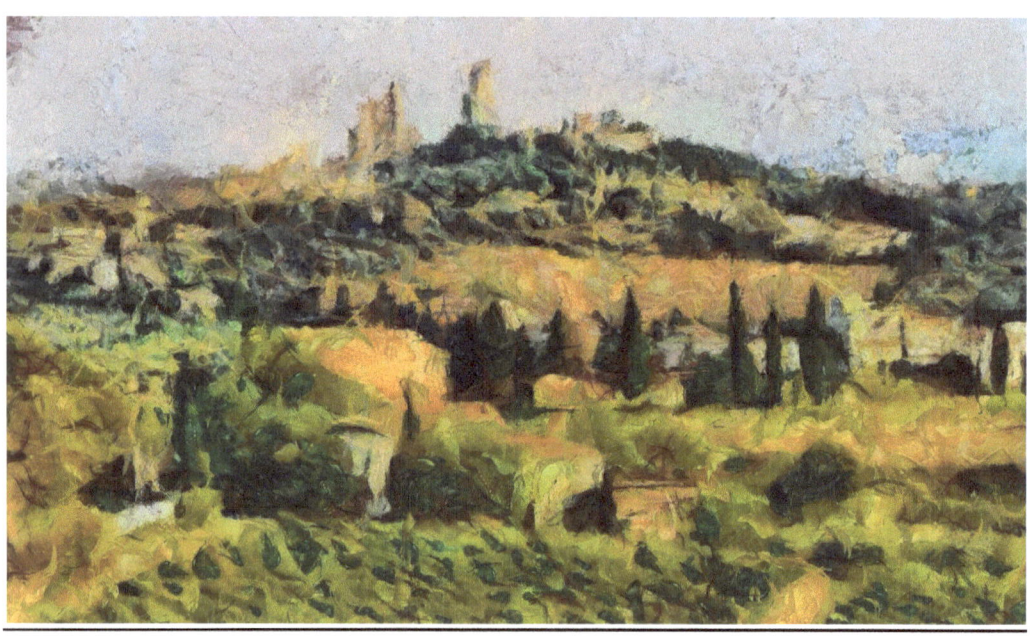

Diamond Art (with different lighting):

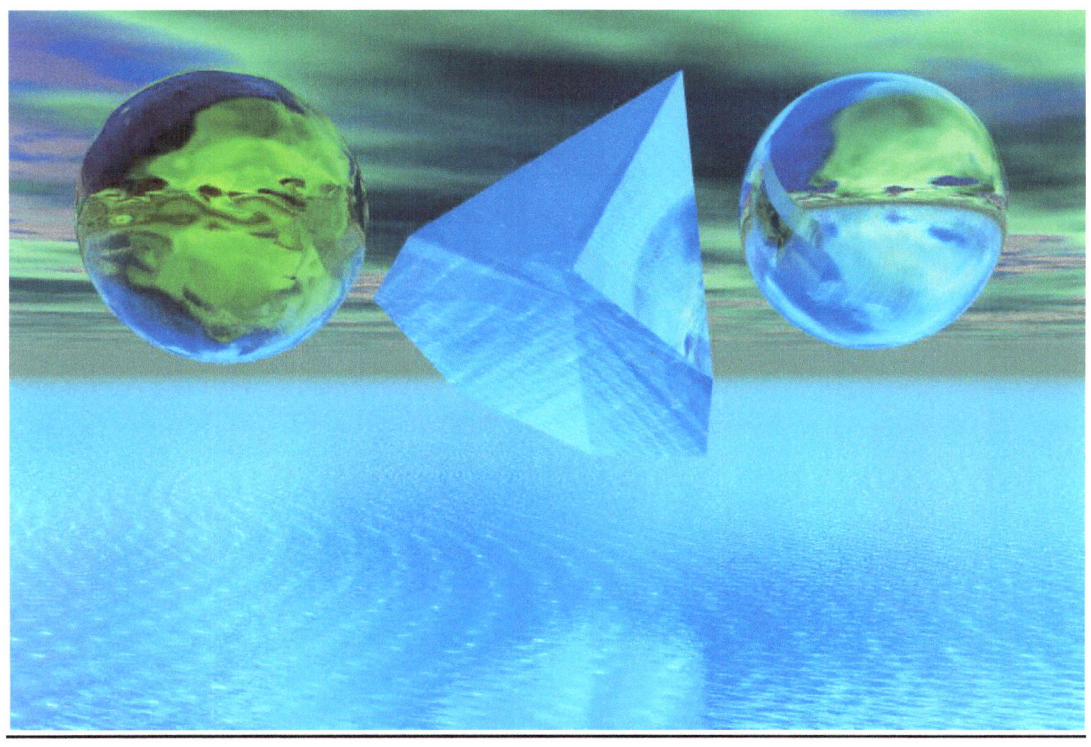

(Gold Sphere, Diamond Prism, Silver Sphere).

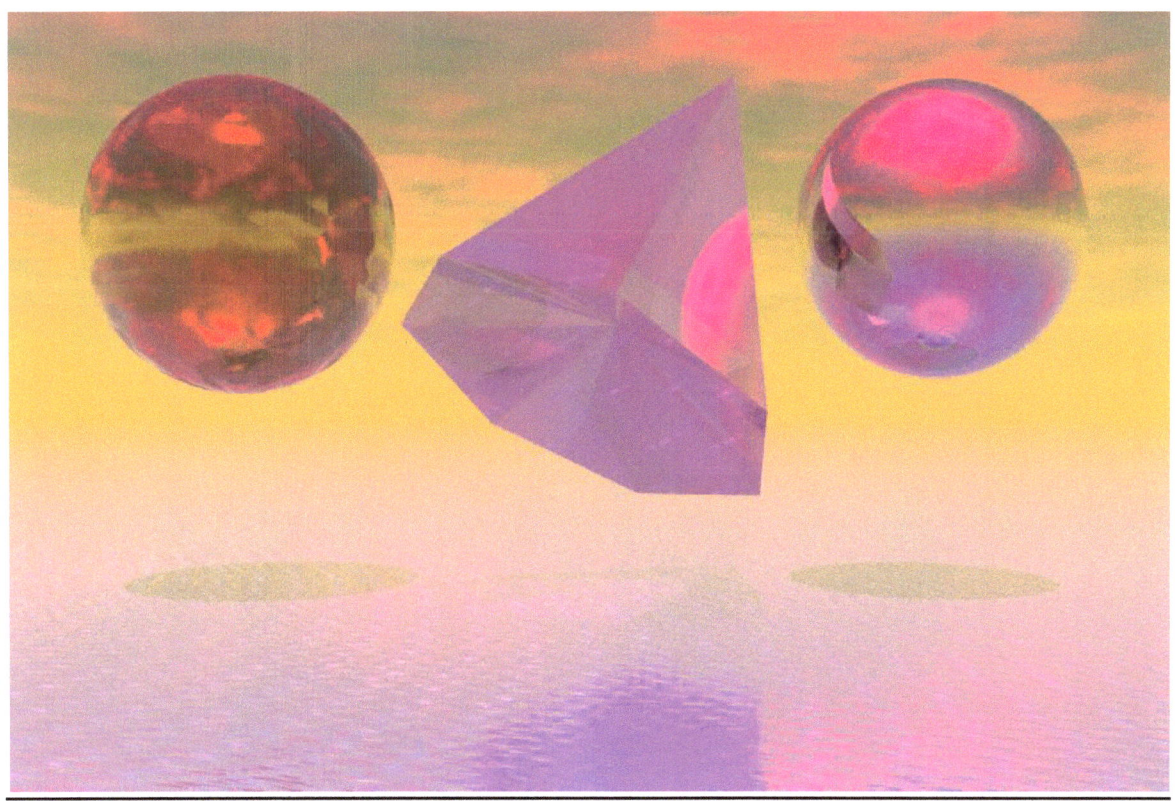

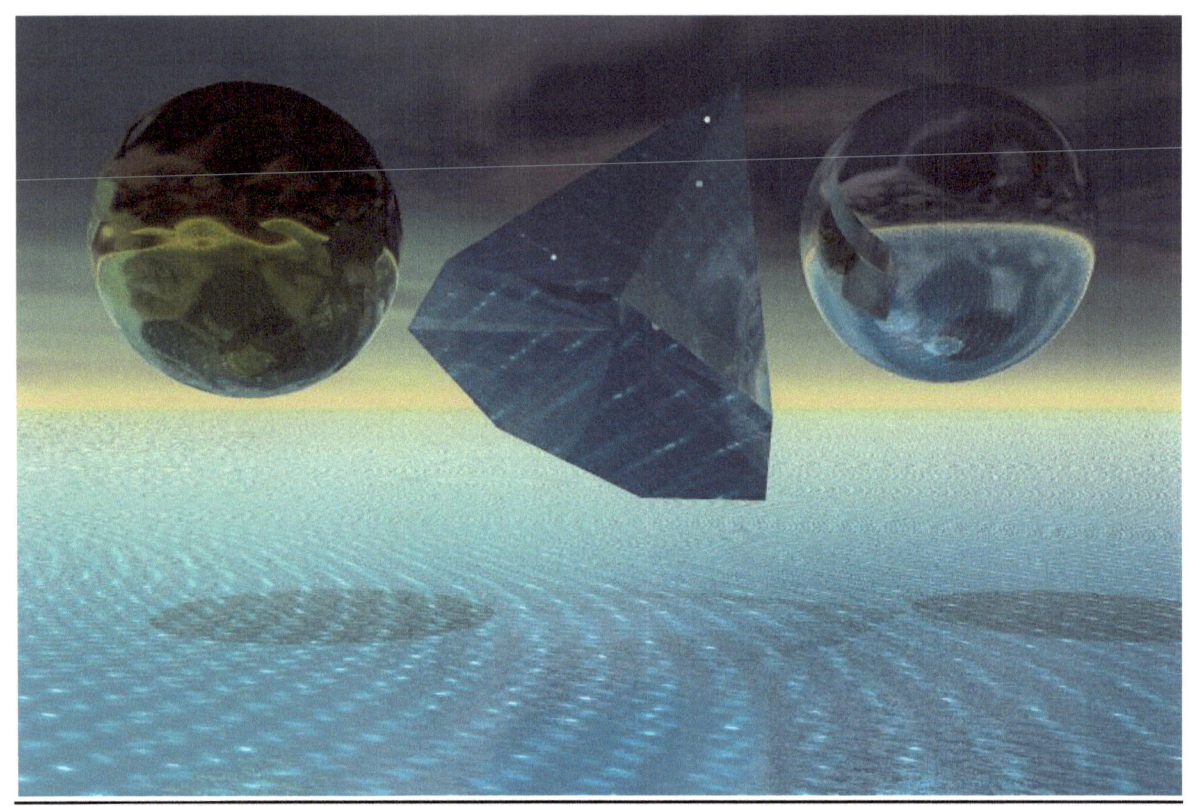
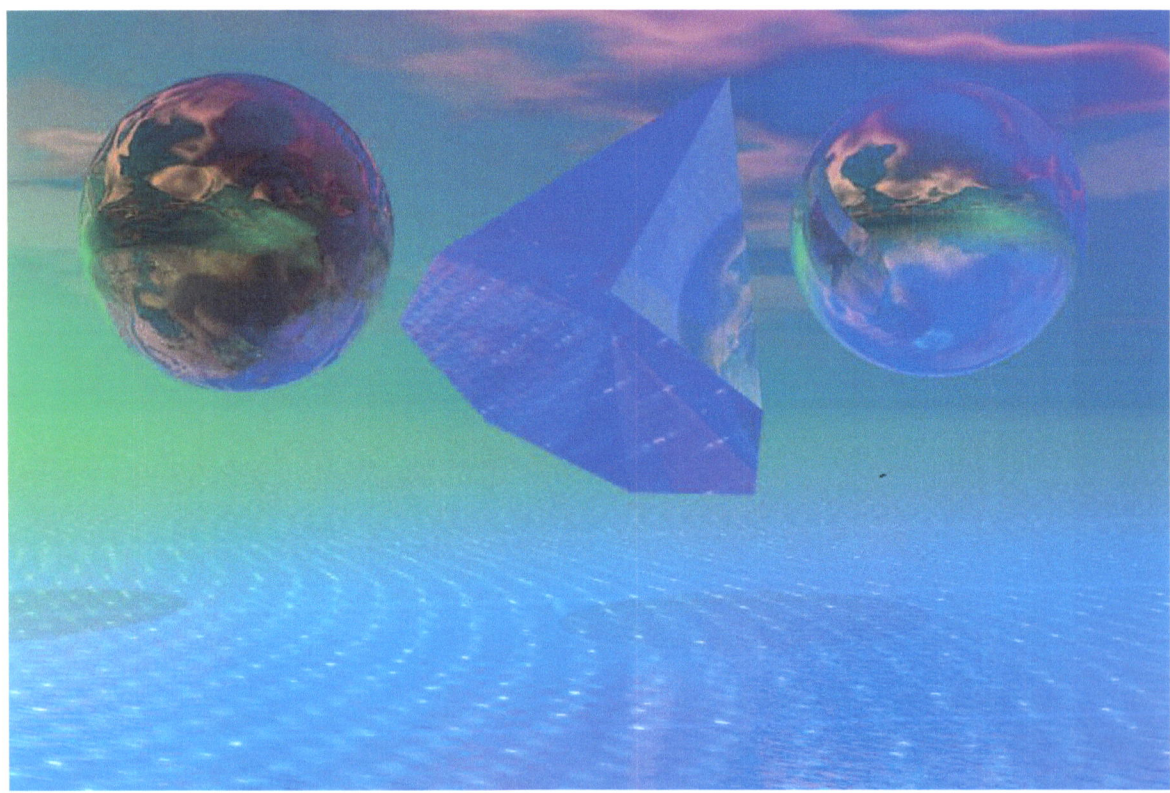

My Abstract Art (simulating Palette Knife):

www.ingramcontent.com/pod-product-compliance
Lightning Source LLC
Chambersburg PA
CBHW050912180526
45159CB00007B/2892